THE VEST POCKET KODAK
& THE FIRST WORLD WAR

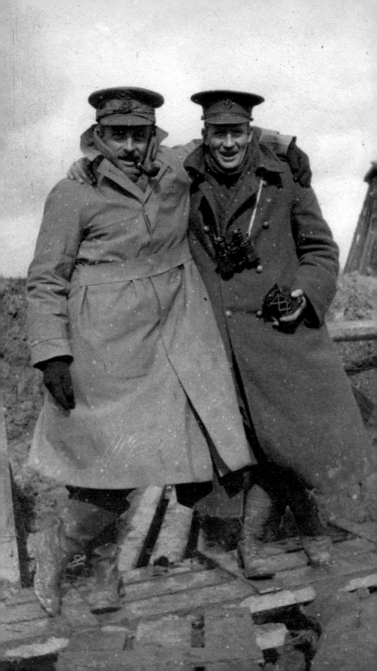

THE VEST POCKET KODAK
& THE FIRST WORLD WAR

Jon Cooksey
foreword by Richard van Emden

AMMONITE
PRESS

First published 2017 by
Ammonite Press
an imprint of Guild of Master Craftsman Publications Ltd
Castle Place, 166 High Street, Lewes, East Sussex, BN7 1XU,
United Kingdom

Text © Jon Cooksey, 2017
Copyright in the Work © GMC Publications Ltd, 2017

ISBN 978 1 78145 279 0

A catalogue record for this book is available from the
British Library.

Publisher: Jason Hook
Design & Illustration: Robin Shields
Editor: Jamie Pumfrey
Picture Research: Jon Cooksey

Colour reproduction by GMC Reprographics
Printed and bound in Turkey

CONTENTS

FOREWORD

It is my view that some of the greatest untapped historical documents of the Great War are the photographs taken by soldiers on their own privately held cameras. These images, many of which have remained locked away in attics, trunks and drawers, give us a fascinating and uncensored glimpse into the often-short lives of the men who served their countries a century ago. They are pictures taken by soldiers who were sometimes under severe strain in front-line trenches and relaxing behind the line, but crucially they are images that mattered to the men themselves – they are scenes that they felt were significant.

Sadly, in too many cases, these photographs – carefully annotated by post-war survivors and lovingly stored in albums – have been consigned to landfill by later generations who failed to recognize the importance of this remarkable photographic legacy. It is also a legacy that has been largely ignored by historians and authors, who have side-stepped these astonishingly revealing and intensely personal snaps to use more readily available images taken by official photographers sent by the War Office to the Western Front – images that are used time and again, to diminishing effect.

It seems curious to me that these photographs have been forgotten when many are of high quality, and were captured by men who came from all walks of life and held almost every conceivable military rank. It is curious because we regularly hear the 'voices' of these same men and their comrades through letters, diaries and tape recordings.

Over the last 30 years there has been a seismic shift in attitude to the Great War. No longer in vogue are the memoirs of generals and field marshals telling a top-down

story of the war in the trenches, backed by reference to regimental books and the war's multi-volumed 'official history'. Instead, the thoughts and opinions of the ordinary soldier have been sought, and with this we have been treated to a new and invigorating story of the war, which provides a new perspective and reveals just how much our fathers and grandfathers achieved. And yet the private pictures that accompany this story have remained sidelined, until now.

I welcome this new book published by Ammonite Press and written by my friend Jon Cooksey. Jon places the private camera on the Western Front in its historical context, telling the fascinating story of how and why cameras were taken to the Front in 1914, why the military authorities felt the need to ban them in the winter of 1914 and why so many soldiers chose to run the risk of court martial to carry on documenting the 'war to end all wars'.

The soldiers' own Great War photography, taken on the first generation of truly portable and robust hand-held cameras, has become a passion of mine. Soldiers took cameras to the Western Front and to other theatres of war because they wished to record their service just as anyone else might wish to record a family holiday – they little knew what awaited them overseas. As a result, their cameras have caught some of the most iconic moments of that war: the Retreat from Mons, the Christmas Truce, the landings at Gallipoli – all moments that would never have been recorded were it not for these men. For that reason we owe them another – albeit lesser – debt, along with our greater and enduring gratitude for our freedom.

Richard van Emden

INTRODUCTION

*I*t was not only their 'troubles' that many of the men – and women – who marched away between 1914 and 1918 packed into their old kit bags. Along with their absolute essentials – mess kit, spare shirt, socks, soap, penknife and 'pull-through' and the other paraphernalia of war – many slipped another, unofficial, item of 'kit' into their pack or tunic pocket: the relatively new, exciting, compact and easy-to-use Vest Pocket Kodak camera – the VPK.

Transported to battlefields around the world by keen amateur photographers, these cherished VPKs were the tools by which the ordinary soldier or nurse would capture – in 'real time' – the significant events of what they recognized would be the single greatest adventure of their lives. No other army in history had been able to record its war in such detail but the men and women of the armies and medical services of 1914–1918 had the technology; they had their trusty VPKs – blatantly advertised as the 'Soldier's Kodak' – and they were determined not to miss a minute.

Battlefield photography was not a new phenomenon. The first ever 'war' photograph depicted a scene from the American–Mexican War of 1846 and the photographs of the Crimean War by Roger Fenton and those taken by Mathew Brady's team during the American Civil War broadcast the gruesome realities of conflict to a wider audience – albeit somewhat staged.

But the technology was cumbersome. Fenton and Brady had used 'wet plate' technology with large, unwieldy cameras needing long exposure times but Kodak launched its new medium for the masses in 1912, just two years before the outbreak of the First World War. The response was astonishing. Thousands invested in the new VPK technology – smaller, lighter, portable cameras using celluloid film which

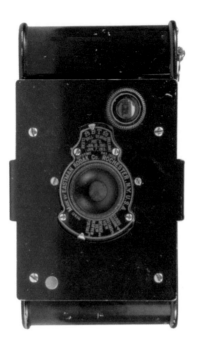

produced images of a consistent quality – and were bitten by the photography bug. A new 'craze' was born. Now ordinary people did not have to rely on professional studios or official photographers as a means of recording their lives and the lives of those around them. They could, and would, do it for themselves. And so they did, in their thousands.

Now, as they marched off to fight the 'Great War for Civilisation', they packed their VPKs and set out on the single greatest journey of their lifetime. They had no idea where that journey might take them or what fate was awaiting, but they would document their days and snap their deeds along the way. Their images – taken by, and of, 'everyman' and 'everywoman' at war – would forever link the VPK to the conflict. The results are in the following pages for all to see.

THE VEST POCKET
KODAK CAMERA

First manufactured: April 1912

Manufacturer: Eastman Kodak Co. Rochester,
New York, United States

Dimensions (closed): 1 x 2 ⅜ x 4 ¾in (2.5 x 6 x 12cm)

Weight: 9oz (255g)

Price: $6.00 (United States) / £1. 10s. (Great Britain)

Shutter: Kodak Ball Bearing Shutter No. 0, three-segment
leaf type, with speeds of 1/25 sec and 1/50 sec, plus B
(Bulb) and T (Time) settings.

With B, the shutter remains open for as long as the
shutter-release button is pressed down. This was typically
used for exposures using flash, when the shutter would be
opened, the flash ignited and the shutter closed.

The T setting is for long exposures. On the first press of
the shutter-release button the shutter opens. On a second
press, the shutter closes.

Lenses: 1912–1914: Fixed focus (6ft/1.8m to infinity)
achromatic meniscus lens with iris diaphragm scaled 1–4.
Zeiss Kodak Anastigmat f/6.9 lens on Vest Pocket 'Special'
models. 1914: Anastigmat f/8.

Film: Produces 8 negative frames measuring 1⅝ x 2½in
(4 x 6.5cm) on side-loaded 127-format roll film.

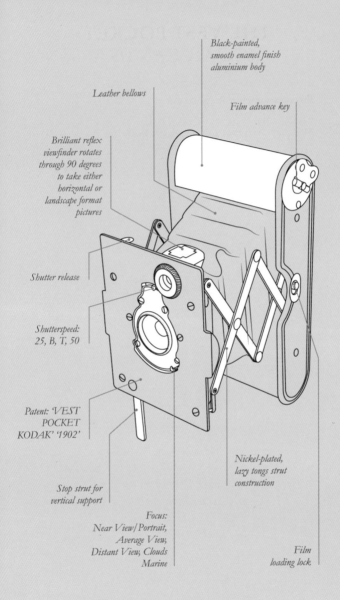

Black-painted,
smooth enamel finish
aluminium body

Leather bellows

Film advance key

Brilliant reflex
viewfinder rotates
through 90 degrees
to take either
horizontal or
landscape format
pictures

Shutter release

Shutterspeed:
25, B, T, 50

Patent: 'VEST
POCKET
KODAK' '1902'

Stop strut for
vertical support

Focus:
Near View/Portrait,
Average View,
Distant View, Clouds
Marine

Nickel-plated,
lazy tongs strut
construction

Film
loading lock

TIMELINE OF THE FIRST WORLD WAR & THE VEST POCKET KODAK

Year	Date	Summary
1912	Apr	Kodak Eastman of Rochester, New York, launches the Vest Pocket Kodak with achromatic meniscus lens. It retails for $6.00 in the United States and £1. 10s. in Great Britain. 200,000 cameras were manufactured before it was discontinued in 1914.
	Jul	Vest Pocket Kodak 'Special' launched with improved Zeiss Kodak Anastigmat f/6.9 lens. British variants would be fitted with one of five different lenses between 1912 and 1915.
1913		Kodak switches identification of all its roll film from camera type to film type, numbering consecutively from type 101. The VPK uses the 27th roll-film format, so takes type 127 film.
		George Eastman pays Henry Gaisman $300,000 for his patent method of 'writing' on photographic film through a slot in the back of a camera. At the time, this was the largest sum paid for a patent by any industrial firm.
1914		The yearly sales of VPKs in Great Britain totals around 5,500 cameras.
	28 Jul	Austria-Hungary declares war on Serbia. Russia mobilizes its troops.
	1 Aug	Germany declares war on Russia.
	3 Aug	Germany unleashes its 'Schlieffen Plan' by invading Belgium, so violating Belgian neutrality.
	3 Aug	Germany declares war on France.
	4 Aug	Britain declares war on Germany. Soldiers begin to land in France, some with VPKs.
	7 Aug	The Battle of the Frontiers begins in France and rages until 13 September.
	23 Aug	The 'British Expeditionary Force (BEF)' fights its first battle at Mons in Belgium. The Great Retreat, or Retreat from Mons, is recorded on several VPKs.
	26 Aug	The BEF fights a holding battle at Le Cateau in France.
	26–30 Aug	Russia and Germany clash in the Battle of Tannenberg on the Eastern Front.

Year	Date	Summary
1914	7 Sep	The Great Retreat ends in the west. France and Britain launch the Battle of the Marne and halt the German advance. Fighting rages until 12 September.
	13–28 Sep	Battle of the Aisne in the west. The fighting spills north, eventually reaching the Belgian coast.
	19 Oct–22 Nov	First Battle of Ypres ends the war of movement. Germany prevented from reaching the channel ports. Trench warfare begins.
	21 Nov	The War Illustrated magazine publishes the first real action shot of the war: 'men of the Middlesex Regiment under fire during the Battle of the Marne,' taken by Lieutenant Robert Cotton Money.
	22 Dec	Sir John French, Commander-in-Chief of the BEF, issues General Routine Order 464 in an attempt to prevent photographs reaching the British press. The Order warns the men of the BEF that: 'The taking of photographs is not permitted.'
	24–25 Dec	The 'Christmas Truce' astride the Franco-Belgian border. Several soldiers, including Lieutenant Robin Skeggs of the 3rd Battalion, The Rifle Brigade, record the seasonal fraternization with their VPKs.
1915	Jan	The Vest Pocket Autographic Kodak is launched. Advertized as 'the soldier's camera', it uses Henry Gaisman's patented special film (a carbon paper between the film and backing paper), which allows photographers to lift a flap at the back of the camera and 'autograph' information on the negatives with a stylus. Around 1,750,000 cameras are produced before it is discontinued in 1926.
	10–12 Mar	The BEF fights the Battle of Neuve Chapelle, the first major offensive in its own right.
	16 Mar	A War Office Instruction is issued in an attempt to ban the use of cameras by British troops. The Instruction states that: 'Any officers or soldiers... found in possession of a camera will be placed in arrest.'
	28 Mar	The SS Falaba is sunk by the German submarine U-28. Fifty people are killed, including Leon C Thrasher, one of the first United States citizens to die. The sinking is captured on film by British army officer Charles Lacon.
	Apr	The Vest Pocket Autographic Kodak Special is launched. The 'special' model has a pin grain leather covering and nickel plated fittings.

Year	Date	Summary
1915	19 Apr	War Office Instruction 173 bans use of cameras outright.
	22 Apr	Germans launch the Second Battle of Ypres with the first use of poison chlorine gas in warfare. Fighting rages until 25 May.
	25 Apr	The Gallipoli landings. British, Australian, New Zealand, Indian and French troops attempt to seize the Dardanelles from Germany's ally, Turkey, and force a route through to Russia. Many Australians take their VPKs to Gallipoli and capture scenes on Anzac beach on the first day. There is no order banning the use of cameras as on the Western Front and some men even develop their own prints on the peninsula. The campaign, however, is a disaster and the Allied troops are evacuated by 8 January 1916.
	9 May– 18 Jun	Second Battle of Artois for the BEF, including the Battles of Aubers Ridge (9 May) and Festubert (15–25 May).
	16 Jun	First Action of Bellewaarde. In the heat of battle, Private Alexander Fyfe of the Liverpool Scottish takes three of the most iconic photographs of the war.
	25 Sep– 6 Nov	Third Battle of Artois/Champagne, including the Battle of Loos (25 September–13 October).
	15 Oct	Britain declares war on Bulgaria.
	27 Oct	The Allies open up the Salonika front.
	21 Nov	Private Ernest James Mullis of 1/5 Gloucestershire Regiment is tried by court martial at Bus-lès-Artois on the Somme and sentenced to three months, imprisonment with hard labour for 'having and using a camera'. Later wounded in action, Private Mullis is discharged on 30 January 1917.
1916	21 Feb	Battle of Verdun begins. Fighting rages until December.
	29 Apr	British forces surrender to Ottoman Turks at Kut.
	31 May– 1 Jun	The first and only large-scale naval battle between the British Grand and German High Seas Fleets is fought at Jutland.
	1 Jul– 18 Nov	Battle of the Somme. Key moments during the battle are recorded on the many VPKs still carried by men of the BEF despite the army ban.
1917	8–11 Mar	The British capture Baghdad.
	6 Apr	The United States declares war on Germany.

Year	Date	Summary
1917	9 Apr–19 May	Battle of Arras and the French Second Battle of the Aisne (Nivelle Offensive, 16 April–19 May).
	31 Jul–10 Nov	Third Battle of Ypres (Passchendaele).
	7 Nov	Bolsheviks seize power in Russia.
1918	3 Mar	Russia signs a peace treaty with Germany at Brest Litovsk.
	21 Mar–18 Jul	The 'last gasp' German spring offensives takes place in the west.
	8 Aug	The battle of Amiens is launched by the Allies, commencing the final Hundred Days Campaign.
	9 Nov	Kaiser Wilhelm II of Germany abdicates.
	11 Nov	Armistice with Germany is signed at Compiègne. The guns fall silent on the Western Front.

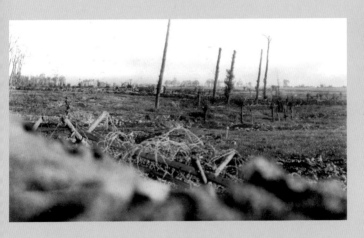

A risky shot taken by Captain Harry Colver over the parapet of a British trench towards the German-held Farm 14, on the other side of no-man's land, north of Ypres. Summer, 1915. White wooden crosses, centre left, mark the battlefield graves of fallen soldiers.

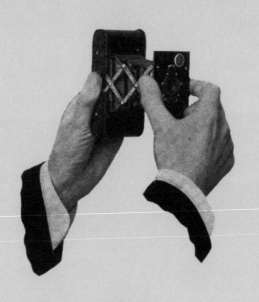

THE CAMERA

PRE–WAR
POCKET CAMERAS

George Eastman's 'Kodak' camera of 1888 epitomized the revolutionary perfection of dry, gelatine-coated photographic plates and their ability to replace wet plates. Buoyed by its success, further developments led to the introduction of rollable film, which made photo-finishing possible and removed technical obstacles for photographers wishing to take 'snapshots'.

Smaller cameras that used 'vest pocket sized' plates first came onto the market in 1892, but many of them were folding plate cameras. However, combined with advances in shutter technology and constantly improving lens quality, daylight-loaded, paper-backed roll film began edging out dry plate technology. It also triggered the trend towards smaller, lighter, more portable and – importantly – cheaper cameras. This removed both the practical and financial barriers that had previously stood before would-be amateur photographers, making photography accessible to the masses.

The capture of images had also become almost instantaneous, and moved even amateurs ever closer to the photographer's Holy Grail – the 'action' shot. Taking good-quality photographs of life events 'as they happened' was no longer the esoteric preserve of the specialist professional, but well within the grasp of the untrained amateur with enough money to purchase a portable camera such as the Boston Camera Company's 'Bull's Eye' of 1892.

Sensing the future, Kodak followed up its original 1888 camera with the 'Pocket Kodak,' a small box camera that produced 1½ x 2in (3.8 x 5cm) negatives that were good enough to satisfy the burgeoning amateur market. With the slogan 'One button does it, you press it,' Kodak sold 150,000 of these cameras before it gave way to the 'No. 0 Folding Pocket Kodak' in 1897 and the Kodak 'Brownie' in 1900.

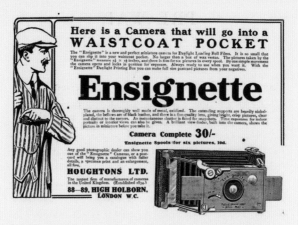

The British-made 'waistcoat pocket' Ensignette directly influenced
the development of Kodak's VPK, which was also priced at
£1. 10s. when it was launched in Great Britain.

Other manufacturers followed suit, with W. Butcher and Sons' 'No. 1 Folding Nipper', Wünsche's 'Kolibri' and Lancaster's 'Pocket Filmograph', all of which appeared between 1903 and 1904.

However, it was the London-based manufacturer Houghton that laid claim to being the first company to produce a really popular, small, roll-film camera. The promotional material that accompanied its brass-bodied, four-strut, retractable 'Ensignette' of 1909 boasted that at ¾in (1.9cm) deep when closed, it was 'a camera that will go into a waistcoat pocket' and depicted the owner slipping one into that very 'vest pocket'. Yet while it was Houghton's Ensignette that most influenced the development of the Vest Pocket Kodak, the latter would eventually outstrip the sales of all of its predecessors on its way to becoming the most iconic VP camera of all time.

THE BIRTH OF THE VPK

Kodak introduced its Vest Pocket Kodak to the world in its 1912 catalogue, declaring that: 'Wherever you are going, however cramped for space, this wonderfully compact little camera can accompany you unobtrusively – and it is always ready for action.'

Although it had been six years since Kodak had ceased production of the No. 0 Folding Pocket Kodak, its compact, built-in, roll-film mechanism and pull-out, strut-supported lens board both offered the potential to be redesigned and re-engineered to fit into a lightweight, all-aluminium body. At the same time the 1⅝ x 2½in (4 x 6.5cm) film format was reconfigured into a smaller cartridge to create what would become known as 127 film in 1913. The result – due mainly to the refinement of the film spool – was a smaller, more compact and lighter camera that was not much bigger than a modern iPhone.

Instantly recognizable thanks to its organic, curved design; shiny, black enamel finish; nickel-plated struts and black leather bellows, the 1912 VPK was fitted with an achromatic meniscus lens, with a higher quality Zeiss Kodak Anastigmat f/6.9 lens offered three months later on the VPK 'Special'. The words 'VEST POCKET KODAK' were inscribed on the bottom of the lens board, with the earliest production run bearing a 1902 patent date.

'So flat and smooth and small as to go readily into a vest pocket, so carefully made as to be capable of the highest grade of work,' gushed Kodak's catalogue, before declaring that, 'Quality marks the Vest Pocket Kodak in every detail.' Amateur photographers now had a window through which they could capture and document their rapidly changing world and the VPK – an icon of form, function and visual democracy – was born.

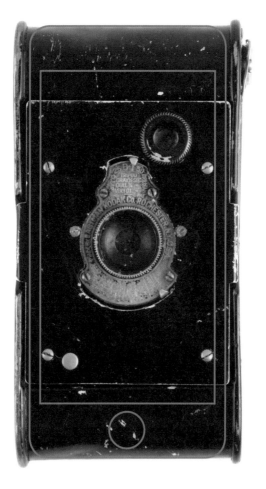

The Vest Pocket Kodak measures just 1 × 2 ⅛ × 4 ¾in
(2.5 × 6 × 12cm).

— *iPhone with 4in (10cm) screen*

THE VPK ON THE EVE OF WAR

The VPK was an immediate hit with the growing ranks of amateur photographers in the United States who were looking for an increasingly light, compact, portable, unfussy and easy-to-operate camera that represented excellent value for money. In Europe, some manufacturers had also recognized the potential of compact cameras, but they simply could not compete with Kodak's slick marketing operation. As Kodak founder George Eastman quipped, the British-made Ensignette had sold in large quantities, 'until we put a better one on the market'.

Kodak prided itself on pushing the boundaries of camera technology and claimed that its faster films, superior lenses and accurate shutters made taking high quality images 'easy under conditions formerly considered impossible'. It was a process the company dubbed 'Kodakery', which was to be distilled into the marketing that surrounded the new Vest Pocket Kodak.

Inspired by the American company's persuasive language, liberal use of half-tone photographs in the pages of the popular illustrated press and the example set by several European royals – including King Edward VII's wife, Queen Alexandra, who was a keen exponent of the Kodak Brownie – hundreds of British subjects were bitten by the photography bug. Overnight it seemed as though Kodakery and the VPK had increased the possibilities and scope of amateur photographers worldwide, contributing to what became a 'craze' for picture taking in Europe in the two years prior to the outbreak of the First World War. By 1914, annual sales of the VPK in Britain reached 5,500.

In the north of England, the photography 'bug' had also bitten Henry 'Harry' Colver. Colver was a part-time Territorial Force officer in the 1/5 Battalion, York and

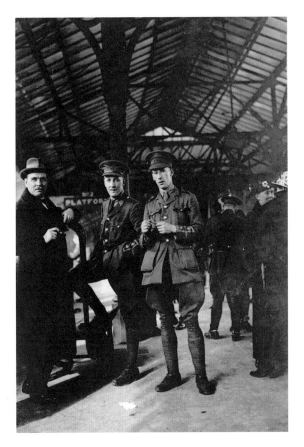

Lieutenant Henry 'Harry' Colver (right) poses with fellow officer Lieutenant Alfred Carr on York station platform as they wait for the train that will take them to Folkestone, bound for France, 13 April 1915.

Lancaster Regiment. Like many soldiers, when war came and he was mobilized, Colver slipped his VPK into his tunic pocket, determined to capture every moment of the greatest adventure of his life. The VPK was marching off to war.

THE AUTOGRAPHIC VPK

George Eastman constantly sought to gain a competitive edge over his business rivals. In 1896 he wrote 'I have come to think that the maintenance of a lead in the apparatus trade will depend greatly upon a rapid succession of changes and improvements… If we can get out improved goods every year nobody will be able to follow and compete with us.'

The original 1912 VPK had been a runaway success in Britain, with many purchasers being soldiers who had been taking photographs since the start of the war in August 1914. So how could Kodak improve on its popularity? The answer was to add an 'autographic' feature using a patent developed by New York inventor Henry Jacques Gaisman in early 1913.

A keen amateur 'Kodaker,' Gaisman perfected a method of taking a photograph and labelling it at the same time to record when and where the images were taken. Gaisman's invention was a special 'autographic film' – a layer of black carbon paper between the celluloid film and its thin red backing paper. Opening a flap on the back of the camera would reveal the autographic film, on which the photographer could add a handwritten note, using a metal stylus. Light would reach the film via the carbon, capturing the note on the negative so that it would appear on the finished prints.

Gaisman's invention was not cheap, though. In 1914, Kodak paid Gaisman $300,000 to sign over all rights to his invention and by August that year was claiming that, 'This autographic feature will… be more far reaching in its effect than anything that has been introduced in photography in twenty years.'

In early 1915, Kodak introduced the autographic technology as a new feature in all of its cameras. Even older cameras could be upgraded to take 'autographic' backs.

Amongst Kodak's newest offerings were the Vest Pocket Autographic and Vest Pocket Autographic Special – with a

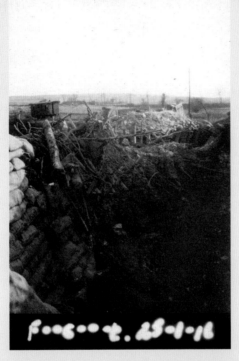

The view over the parapet of the British front line by Lieutenant Richard Hawkins of the 11th Battalion, the Royal Fusiliers. Hawkins added the date (25.1.16) and made a thinly disguised attempt to record the location: 'F..c...t' was the German-held village of Fricourt.

range of lenses. According to Kodak, the new feature turned the camera into a 'veritable vest pocket notebook' and it proved so popular that 28,000 VPKs were sold in Great Britain in 1915. Now soldiers could not only take photographs, but could record the names of their comrades, the trenches they held and the shell-torn German villages on the other side of no-man's land so they would not forget a single detail when – or if – they returned home.

ADVERTISING THE VPK

Kodak's relentless marketing operation was well established by the time the VPK was launched in April 1912. The Kodak exhibition that had toured Britain in 1904–1905 had, according to *The Amateur Photographer* and *Photographic News*, stirred up popular enthusiasm for photography 'like a revolutionary banner' as it moved from town to town.

In September 1913 Kodak launched its own magazine, *Kodakery*, which was designed to feed the interests and secure the loyalty of this new mass market. Page 17 featured a photograph of British soldiers handling equipment in a tented camp above the headline 'Getting Europe into your Vest Pocket.' Presciently, less than 12

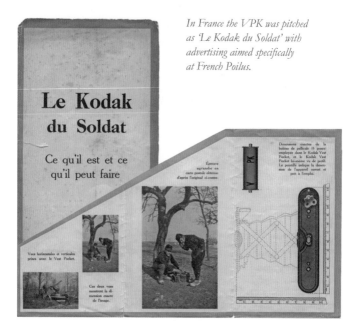

In France the VPK was pitched as 'Le Kodak du Soldat' with advertising aimed specifically at French Poilus.

months before Europe was plunged into catastrophe, the article pointed out that, 'There is a great deal of Europe and very little to a pocket, but that marvel of portability, the Vest Pocket Kodak solves the problem. In Europe there are so many things to make that button finger "itch"...that this ready means of seizing each of them in a moment's time furnishes a never ending gratification.'

When war broke out in August 1914, it is thought that 1 in 5 British officers had packed a VPK in their kit. When the first images taken by these soldiers with 'itchy' button fingers began to appear in the pages of the British press, Kodak sensed a vast untapped market as hundreds of thousands of men served in armies across the globe.

In 1913, Kodak had already boasted that the VPK was 'as small as your notebook and tells the story better'. However, after the introduction of the new Autographic VPK in January 1915, and with British newspapers like the *Daily Sketch* and *The Daily Mirror* promising huge cash prizes of £600–£1,000 for 'real war photographs', it went further and started marketing the VPK as 'The Soldier's Kodak' in Britain, Australia, Canada and New Zealand; as 'The Kodak of the Soldier' in France; for 'Every Officer and Soldier' in Italy; and 'A welcome gift for the soldiers' in the Austro-Hungarian Empire.

A Canadian Kodak Trade Circular from January observed that there were upwards of 25,000 men in training camps who would leave to fight on European battlefields and asked its dealers, 'Have you stopped to consider the purchasing power of these thousands of officers and men...of the possibilities for creating here the demand for a Kodak that will enable the soldier to tell his own story of the great war...This he can well do and easily with the little Vest Pocket Kodak. No camera is better suited to the requirements of a soldier in training camp or at the front...the ideal soldier's Kodak.'

USING THE VPK

Studying the images captured by the VPK during the First World War, one senses that the vast majority were what Kodak called 'instantaneous exposures' or 'snap shots'. While some very keen soldiers – and nurses – had an eye for composition and undoubtedly 'arranged' scenes for artistic purposes, the very nature of the war lent itself to snapping 'real life' in 'real time', fixing forever on celluloid the daily round of the man or woman at, or near, the front line.

The evidence of excellent unofficial images is overwhelming in archives and private collections today, but how, physically, were the photographs taken? How easy was the VPK to use? Being light and compact the VPK had become popular very quickly, but another reason that was crucial to its commercial success was the ease with which anyone – even children, according to Kodak – could operate the camera and achieve good results.

The camera used either 127 format film or special A127 light-proof roll-film cartridges for autographic results in the Autographic models from 1915 onwards. To load either film, the photographer released a catch and removed the top of the camera with the thumbs of both hands. One end of the film

was then threaded into an empty metal spool and tightened to engage the unexposed film before both spool and film cartridge were loaded into one of two tube 'pockets' at each end of the camera. With the top replaced, the film was reeled off with a winding key by around 15–18 half turns, until the number '1' became visible through a red window at the back.

To make an exposure, the photographer had a choice of operations. The shutter could be set using a scale at the top for T (Time), B (Bulb) or an 'instantaneous' exposure could be made at 1/25 sec or 1/50 sec. Further variations could be achieved by setting another scale at the bottom according to the type of subject and surroundings. Most exposures were 'instantaneous', especially the few that were taken over the parapets of trenches!

Once the camera was set, the scene was brought into focus by pulling the lips at the front to extend the bellows. Now came the crucial moment – taking the photograph. Holding the VPK firmly against the body at chest height with the sun at the back, the photographer looked down into the viewfinder – the camera either vertical or horizontal – to locate the subject and compose the shot. Then, catching his or her breath for an instant to hold the camera level and minimize any 'shake,' the shutter-release lever was pressed and history was recorded.

THE NEWS GETTER

In the hands of the new breed of amateur photographers, Kodak was well aware of the deep and lasting significance that its products – including the VPK – would have in documenting the war. The following article appeared in the company's *Kodakery* magazine of May 1915:

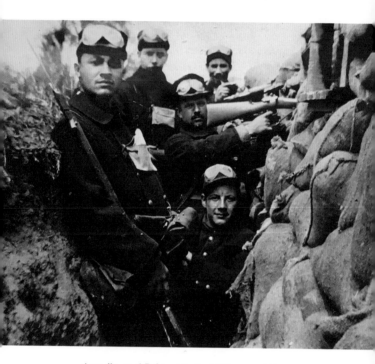

A small part of Belgium's 'valiant little army which…so immortalized itself' pictured here in a narrow, rudimentary trench on the northern sector of the Western Front.

'The war is establishing the Kodak amateur in a brand new field of usefulness. From a popular pastime his Kodak turns to chronicle world events. From the romance of the summer wood it turns to tell the romance of war.

And it is doing this work of war recording with graphic realism, absolute impartiality and splendid pictorial charm. In the hands of War Correspondents and more or less expert war photographers, the Kodak, of course, has long ago seen active service. It was in the trenches of Santiago with Dinwiddie; Dunn used it in [Korea]; James H Hare the famous war photographer, used it in the last Balkan war, and is using it in this. The present, however, is probably its first war experience in the hands of amateurs. Thousands of Kodaks are in the kits of soldiers at the front. Thousands more are in the hands of civilians within the war zone. And the shutters of all these are busy "getting" the story of the greatest of all wars, as only pictures can…With the Kodak in our hands the past can never get very far away from the present again. This is photography's incalculable service to mankind.

…the amateur becomes an important arm of the newspaper service, or a chronicler, possibly, of world events. Many Kodakers' landmarks the war has destroyed; but the records of points of interest like Malines, Rheims, Brussels and Ostend are preserved in indestructible film. This fact alone would put the world under everlasting obligation to photography. Some of the pictures…tell the story of the remnants of Belgium's valiant little army, which has so immortalized itself. Others tell of the flight from Belgium, with an intimacy and pitiless detail that is only possible to Kodak records. Still others show the present condition of cities that stood in the path of the destroyer. And in contrast to the horror and gruesomeness of these – its mission of humanity knowing neither race nor creed, friend nor foe – are scenes from the work of the Red Cross. Among these latter pictures are some of the most interesting and intimate human documents ever published.'

USE BY ALLIED SOLDIERS

In August 1914, hundreds of British soldiers took their VPKs to France in what many expected to be a short, but 'glorious', war of adventure. Their hope was to capture their part in what they sensed would be the greatest test of their lives, just as they had snapped their escapades on holiday in peacetime.

Understandably, given such an existential crisis, the popularity of the amateur photography craze among the soldiery was not a high priority at the War Office and the wisdom of soldiers taking their own cameras to the front was never questioned. With no-one checking on the numbers of cameras carried (more often than not by officers), or the content of any photographs taken, the men of the British Expeditionary Force (BEF) began snapping away immediately, charting every twist and turn of the embarkation, the channel crossing, the march to the front and eventually the fighting.

Many officers documented the early months of the war in great detail, from the first engagements at Mons and Le Cateau in August 1914, through the Great Retreat, the battles of the Marne and the Aisne in September and the onset of trench warfare during the winter of 1914–1915. One of those officers was Major Thomas Stanton Lambert. While serving as second-in-command of the 1st Battalion, East Lancashire Regiment, Major Lambert took more than 100 photographs between his embarkation on 21 August 1914 and his return home, wounded and invalided, on 7 November the same year. Several of his images show men in action, while others picture senior officers such as the then Brigadier General, Aylmer Hunter-Weston, who by 1916 would become a lieutenant general in charge of an army corps. It was not until the War Office clamped down hard on the possession of cameras in the spring and early summer of 1915 that the trend set by men such as Major Lambert started to fade.

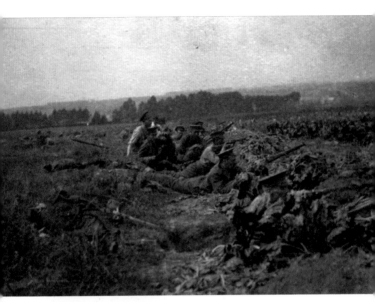

The rough-and-ready trenches of the 1st Battalion, East Lancashire Regiment, south of Solesmes, France, 25 August 1914.

The East Lancashire Regiment reached Le Cateau at 7.30pm on 24 August. En route they heard of the German advance from Mons, and early on 25 August they 'dug in' on the high ground south of Solesmes. It was here that Major Thomas Stanton Lambert (left) recorded this image of his men in their shallow rifle pits.

MADONNAS OF PERVYSE

Elsie Knocker holding her Vest Pocket Kodak camera, photographed by Mairi Chisholm while standing outside the aid post with Belgian officer Major Georges Gilson of the 9ieme de Ligne (9th regiment of the line), at Pervyse in late 1914.

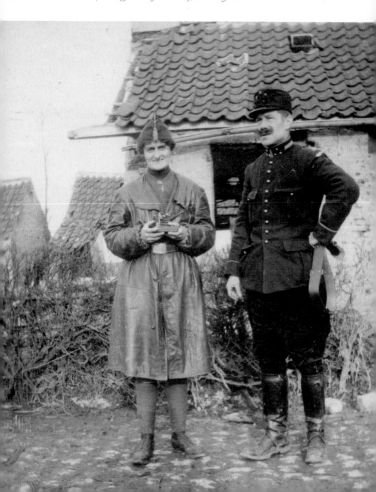

Prior to August 1914, Elizabeth 'Elsie' Knocker and her friend Mairi Chisholm were two women ahead of their time. Both were keen amateur photographers and motorcycle enthusiasts and when war broke out, Knocker suggested they become dispatch riders for the Women's Emergency Corps. Chisholm later transferred to Hector Munro's Flying Ambulance Corps and crossed the channel for Belgium in September 1914, joined by Knocker, a skilled nurse, mechanic and driver who spoke fluent French and German. Both had their VPKs packed in their luggage.

By the end of October 1914 the friends were based in Furnes on the Belgian coast, driving back and forth to pick up wounded soldiers from behind the front line and ferry them back to a field hospital. This was not enough for the redoubtable pair, though, and convinced that more lives could be saved if the wounded soldiers were treated closer to the front line, Knocker and Chisholm struck out on their own.

From November 1914 they set up several First Aid Posts – known variously as 'The Sick and Sorry House' or the 'Poste de Secours Anglais' – and a soup kitchen around 100 yards (91m) behind the front line at Pervyse. For the next three and a half years they worked tirelessly, raising money for their operation and risking their own lives to save others, only leaving Pervyse after they were badly gassed in 1918. Both were awarded the Belgian Order of Leopold II in 1915 and the British Military Medal in 1917 for their bravery.

As they were officially seconded to the Belgian garrison of Pervyse, Knocker and Chisholm were not subject to British authority, or the rules on carrying and using a camera. The women – who became known as the 'Madonnas of Pervyse' – were therefore free to photograph each other, their aid posts and the Belgian soldiers they worked alongside or treated. In doing so they not only created a photographic legacy of their own, but also became some of the most photographed women of the war.

IN THE HANDS OF
GERMAN SOLDIERS

Recording the significant events of the war was not merely the preserve of Allied soldiers. Although censorship in Germany was controlled by the military, the German Kaiser had recognized the potential of photographic propaganda as a weapon of war by authorizing 19 'court' photographers – including the then-neutral United States photographer Albert Dawson – to shadow his army moving into Belgium in August 1914.

Intended to fire the patriotic spirit at home, images of German soldiers beating the Belgians into submission were instead manipulated by the allies to depict the 'rape of Belgium', inciting shock and outrage in Britain and the United States. Despite military censorship, German soldiers were actively encouraged to take photos of their comrades in both the Western and Eastern theatres to illustrate the unity of purpose, camaraderie and confidence of the men at the front for those in the 'homeland'.

Urged on by the *Deutsche Gesellschaft der Photografie*, families were also encouraged to send cameras to men at the front in 1915. The resulting images, which found their way into albums or were turned into picture postcards to be sent home, were often shocking. Provided cameras were not used in combat, German troops were at liberty to photograph dead allied soldiers to convey the grisly message that slaughter was the only logical consequence of attacking 'impregnable' German positions. The sheer number and availability of front-line photographs quickly made professional shots redundant, as the authorities could collect rather than generate images. By the end of November 1915, it was estimated that some 45,000 photographs had been gathered.

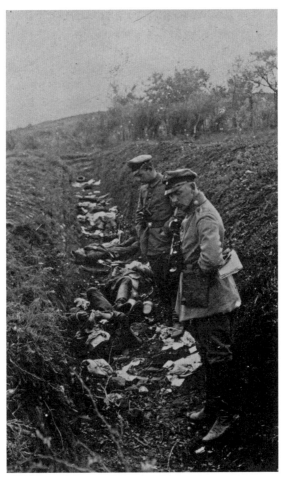

Leichenlinie: *A German officer (right) and* Unteroffizier *(corporal) of an artillery unit gaze impassively on the corpses of several enemy soldiers in a scratch trench at an unknown location on the Western Front.*

THE VPK AND THE
GLOBAL CONFLICT

In what was a truly global war, VPKs were used beyond the Western Front in areas many senior officers saw as 'sideshows'. German and Austro-Hungarian soldiers used them on the Eastern Front, while cameras were carried by British soldiers to Salonika, Italy and Mesopotamia, and by British, Australian and New Zealand troops to Gallipoli. Indeed, some of the most evocative images of the Gallipoli campaign are those snapped by Sydney Webb, a 23-year-old watchmaker who was serving as a sapper with the New Zealand Field Engineers.

At the same time that Webb was on Gallipoli, Lieutenant Colonel Henry Jourdain had formed the 5th Battalion, the Connaught Rangers, and had landed at Anzac Cove on 5 August 1915. Jourdain also took photographs on Gallipoli, until late September, when the Connaught Rangers were shipped to a new front that had opened up in Salonika. Jourdain's images documented a campaign fought in a region with high mountains and deep valleys against a Bulgarian adversary. Yet more than that, they also tell the story of a commanding officer flouting a ban on the use and possession of a camera in all operational theatres, something that had been ordered by the British Army eight months previously.

From the rugged mountains and gullies of Gallipoli and Salonika, to the heat and dust of the desert and the campaign against the Ottoman Empire in Mesopotamia, it seemed that despite orders to the contrary, VPKs were on hand to record the experience.

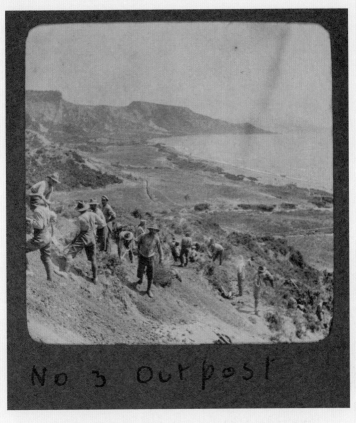

No 3 OutPost

Taken by Sydney Webb from the slopes above the curving bay at Anzac Cove, the photograph clearly shows the weather beaten bluff (top left) that towered above the Anzacs throughout their time on the peninsula. As many had travelled through Egypt on their way to Gallipoli it was not surprising that they christened it 'The Sphinx'.

CENSORSHIP

The first uncensored 'action' shot of the war appeared in the new wartime weekly, *The War Illustrated*, on 21 November 1914. The photograph depicted the transport column of the 1st Battalion, Middlesex Regiment, under artillery attack, complete with a wounded officer. Fearing a loss of control at home and the potential intelligence and propaganda value should soldiers' uncensored images fall into the wrong hands, the British Army issued a General Routine Order (GRO) just before Christmas 1914.

The Order stated that: 'The taking of photographs is not permitted and the sending of films through the post is prohibited. Any officers or soldiers (or other persons

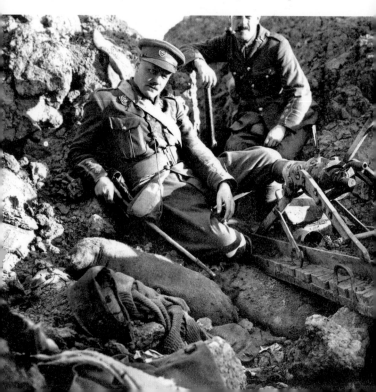

subject to military law) found in possession of a camera will be placed in arrest, and the case reported to the General Headquarters as to disposal.' However, this did not stem the flow of 'uncensored' photographs reaching the press, and the authorities were further shocked when images of British soldiers smiling and openly 'fraternizing with Fritz' in no-man's land at Christmas 1914 appeared in the press in January 1915.

Part of the problem was that the 1914 GROs had been a local 'fix' for the Western Front, so those still to sail for France were unlikely to see or hear of it. To overcome this, a catch-all War Office Instruction (WOI) was issued in March 1915, banning the possession and use of cameras in all operational theatres. Throughout the remainder of 1915 warnings against having cameras were re-issued in a series of GROs to reinforce the importance of the ban, and many officers and men duly sent their cameras home. Some, however, ignored the order and continued to snap away, often with the knowledge of their superiors. Indeed, the ban was not enforced on Gallipoli, where perhaps as many as 1,000 VPKs were carried by Anzac troops.

On 18 September 1915 – seven months after the WOI banning the possession and use of cameras – Captain Harry Colver photographed machine-gun officer Captain Rideal and another unknown officer of the 1/5 Battalion, York and Lancaster Regiment, posing proudly with a German Lanz minenwerfer, abandoned when 'International Trench' was captured by the British in July.

TAKEN BY A BRITISH OFFICER

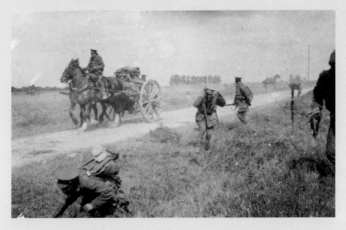

'Troops of the 1st Battalion, Middlesex Regiment (Duke of Cambridge's Own), under shrapnel fire from German artillery on the Signy-Signets road, 8 September 1914.'

The photograph above, taken during the early weeks of the First World War, was the very first 'action' shot of men under fire to appear in print; as such, it can truly lay claim to having achieved 'iconic' status. It was taken by Lieutenant Robert Cotton Money, an officer of the 1st Battalion, the Cameronians (Scottish Rifles), and printed with the caption: 'Troops of the 1st Battalion, Middlesex Regiment (Duke of Cambridge's Own), under shrapnel fire from German artillery on the Signy-Signets road, 8 September 1914. The man with the goggles belongs to the Intelligence Corps. He is badly wounded in the head and his face is covered with blood.'

The British press, including new publications such as *The War Illustrated,* were ravenous for shots from 'the front', as they were otherwise reliant on images supplied by international press agencies, taken far from the action.

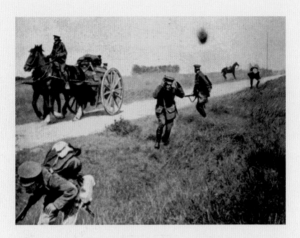

The edited photograph, 'taken by a British officer,'
The War Illustrated, *21 November 1914.*

The image, trumpeted as being 'taken by a British officer,' was the 'scoop' the papers required, appearing as a half-page feature in the 21 November 1914 edition of *The War Illustrated*. However, the photograph that appeared in print was heavily doctored – a bursting shell was added to enhance the real and obvious danger captured in the original.

According to the 1st Battalion, Middlesex Regiment, war diary, the artillery fire killed nine horses, but all of the transport was saved. Three men were killed and 30 wounded. Given the specific mention of an intelligence officer in the original caption, research by Helen Carter points to the badly wounded man being Second Lieutenant Alfred Sang. His entry in the book, *Bond of Sacrifice*, indicates that Sang was wounded by shrapnel 'on or about 9th September 1914' and died of his wounds in, Rouen, France on 2 October 1914.

THE CHRISTMAS TRUCE

Some of the most remarkable – indeed sensational – images of the war were taken with the VPKs of British soldiers manning the front-line trenches in late December 1914. As both sides prepared to mark the first Christmas of the war and a seasonally crisp, hard frost set in along the line, a spontaneous and highly unofficial truce broke out on sectors of the British front straddling the border from just north of Ploegsteert in Belgium to the south of Armentières in France.

Robin Skeggs was a young second lieutenant and keen amateur photographer with the 3rd Battalion, the Rifle Brigade, which was at that time holding the line opposite the German-held village of Wez Macquart. A few days before Christmas he had written to his parents telling them that he had intended sending, as a Christmas gift, some 'photos that I have taken…just amusing little incidents and persons which are the sideshows of the war'.

The photographs taken on Christmas Day 1914 would, however, be far more historic. In a letter to his father, Skeggs wrote that at 6.00pm on Christmas Eve the Germans began shouting: 'Vee veesh you a merree Christmas – Vee vill play ze football wid you to-morrow' across no man's land, with his riflemen replying in their own inimitable way "Garn, 'oo are yer getting' at?"' On Christmas morning his servant woke him to announce that 'everyone was walking about all over place… The feeling gradually came over one that there really was a truce, and after several people had stood up on the parapet just to test matters, three of us officers walked over towards the Boche armed with nothing but papers, cigarettes and chocolate. They immediately came out and met us half way, and were quite affable… They signed postcards for us. We then said good day, and withdrew. This started the ball rolling and for the rest of the day there was a perpetual stream of men from the trenches to the halfway point.

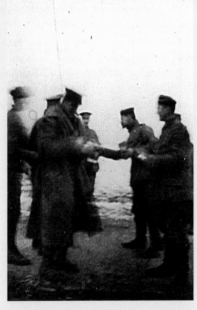

Second lieutenant Robin Skeggs's images of the Christmas Truce that took place on the road between la Chapelle d'Armentières and Wez Macquart. He later noted his frustration that he had not held his VPK still and had not taken more photographs of this historic event.

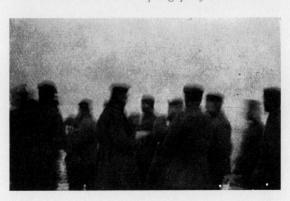

They shook hands, exchanged newspapers, they talked, exchanged cigarettes for cigars, they lit their smokes from the other fellow's cigarette, and generally did everything you wouldn't expect them to do. There were over a hundred men from each side in the group once. There is a road which runs through our lines to the German lines...and this was the common rendezvous.'

Skeggs took his VPK and snapped the iconic scenes and his images – slightly blurred – tell the remarkable story of a young man who, nervous and excited, felt the weight of history on his shoulders in attempting to capture such a momentous event on film. He was later to record that he was furious with himself for not holding the camera still and not taking more images. 'I am so glad you like the photographs,' he wrote to his father, adding that there were 'too many of me and not enough Germans to be of real interest.'

Robin Skeggs secured the autograph and address of a German soldier in no-man's land on Christmas Day 1914.

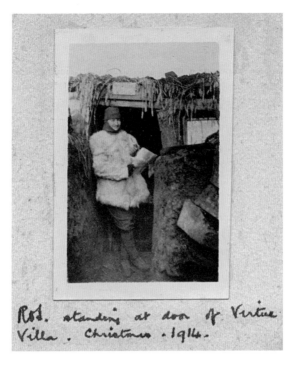

Rob. standing at door of Virtue Villa. Christmas. 1914.

Second Lieutenant Robin Skeggs wraps himself up in his goatskin fleece outside 'Virtue Villa', his dugout in the trenches south of Armentières, Christmas 1914.

Other photographs, depicting scenes of friendly Germans shaking hands and exchanging gifts with equally amiable British troops, appeared in the press. These shocked the British authorities seeking to portray the 'demon Hun' as the barbaric face of a brutal regime, and a comprehensive ban on cameras was introduced three months later.

CROWDED COVE

According to Dr Peter Pedersen, a leading Australian military historian, this is the single most important image taken on the day of the Gallipoli landings for Australians. It even ranks as one of the most important of the entire campaign as it directly contradicted a version of events that appeared in the Australian official history on the matter of men 'straggling' away from the fighting on that fateful day.

In this image, taken on the beach at Anzac Cove in the late afternoon of 25 April 1915, the day of the Gallipoli landings, an Australian soldier rests against a low earth bank and gazes intently into the camera lens. Centre stage, he appears almost serene given the chaotic scene being played out behind him as scores of Australian soldiers, in both peaked caps and slouch hats, turbaned Sikh gunners of the 7th Indian Mountain Artillery Brigade and medics wearing 'red cross' armbands, mill around amid piles of personal equipment, stretchers, boxes and stores. A shirtless man with a bloody chest wound, a cap covering his face, lies supine in the foreground.

As the shutter closed to preserve this image, fierce fighting was still raging inland, along what was dubbed 'Second Ridge', yet stragglers had been drifting back down to the relative safety of the beach for several hours. When the British official historian Charles Aspinall-Oglander suggested in 1926 that this straggling had assumed almost epidemic proportions he was condemned by Australian official historian Charles Bean, surviving veteran officers, the Australian press and

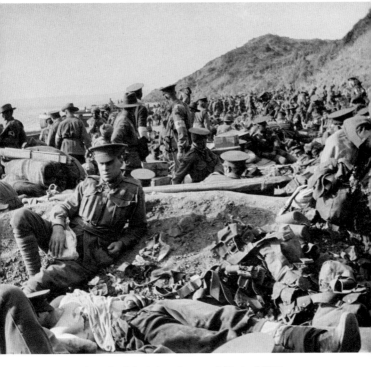

Anzac beach in the late afternoon of 25 April 1915.

former Prime Minister Billy Hughes. Consequently, the issue never became a matter of public record in the British official history. Yet this remarkable photograph – part of a collection of 30 Gallipoli images that originally belonged to Major Charles Atkins, an Australian doctor – confirmed the extent of the straggler problem and is testament to the general disorganisation and loss of control by inexperienced Anzac commanders towards the end of the first day.

LIVERPOOL 'JOCKS'

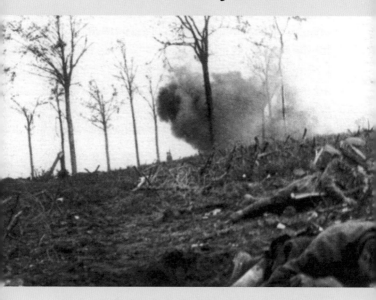

Photographs from the crucible of combat are rare, especially those taken after the official ban on the use of cameras in March 1915, so the images taken by 25-year-old Private Frederick Fyfe of Z Company, 1/10th Battalion, the King's Liverpool Regiment (Liverpool Scottish) on the Bellewaarde Ridge, east of Ypres, on 16 June 1915 are truly remarkable.

In his series, Fyfe recorded men advancing or taking cover under the parapet of the captured German front-line trench on the tactically vital ridge north of Hooge. It was around 6.00am, during his battalion's advance in the First Action of Bellewaarde, and Fyfe himself was wounded and sheltering beneath the parapet. In the photographs an artillery forward observation officer, having just negotiated the German barbed wire entanglements, moves up, crouching as shells burst in Railway Wood behind him, to join kilted men of the

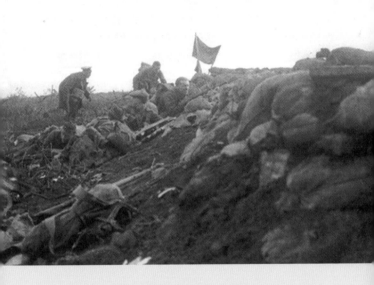

'Scottish' who are already taking cover. To the right, a marker flag indicates the progress of the attack to the British artillery.

The attack, launched less than two hours earlier, succeeded in ironing out a kink in the German line and gained 252 yards (230m) of higher ground on the ridge, pushing the apex of the Ypres salient even further east. The cost was enormous, and the Liverpool Scottish practically ceased to exist: of 23 officers and 519 men, only two officers and 140 other ranks came out unscathed. In all, more than 3,500 men of the British 3rd Division became casualties.

However, when they appeared in *The War Illustrated* on 10 July 1915, Fyfe's images had been manipulated for propaganda purposes, with a 'dead' German soldier and *pickelhaube* helmet substituted for the kilted Liverpool Scot lying prone in the foreground.

THE THRASHER INCIDENT

On 28 March 1915 the British steamship *Falaba* – en route to Sierra Leone – was torpedoed in St George's Channel by the German submarine U-28. Resting in his cabin when the *Falaba* was hit was Charles Lacon, an officer of the Royal Warwickshire Regiment. Dressing quickly, Lacon went on deck to find out what had happened and was preparing to jump overboard when he felt his camera in his pocket. Deciding to stay, Lacon wandered the decks as the ship listed, photographing passengers in lifeboats or clinging to upturned rafts in the water.

When the German submarine surfaced and its crew lined the deck, he photographed them too, and when the *Falaba*'s funnels were almost level with the water, Lacon finally stopped snapping, wrapped his camera in his mackintosh and jumped into the sea. He clung to a plank for over an hour before the trawler *Eileen Emma* fished him out. Carefully unwrapping his camera, he found the leather case ruined, but the camera – and more important, the film – was safe.

In all, 53 crew and some 50 passengers on board the *Falaba* died, but crucially that number included a US citizen – a 31-year-old mining engineer named Leon C. Thrasher. His loss led some in the US to call for a response – even war – against Germany, and what became known as the 'Thrasher Incident' caused diplomatic tensions to rise.

Sensing the gravity of the incident, Charles Lacon offered his film to *The Daily Mirror*, which paid him £200 and later awarded him £1,000 for the best war picture. Lacon's remarkable photographs made a huge impression both at home and abroad. The headline in *The New York Times* of 31 March 1915, proclaimed '*PHOTOGRAPHS TAKEN ON SINKING FALABA… Englishman Went About, Camera in Hand.*'

At home, *The Daily Mirror* claimed the way Lacon had taken the photographs was 'a romance in itself'. After the explosion, Lacon, it reported, had calmly helped to lower

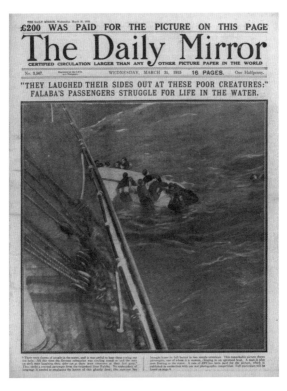

The Daily Mirror

CERTIFIED CIRCULATION LARGER THAN ANY OTHER PICTURE PAPER IN THE WORLD

WEDNESDAY, MARCH 31, 1915 16 PAGES. One Halfpenny.

"THEY LAUGHED THEIR SIDES OUT AT THESE POOR CREATURES:"
FALABA'S PASSENGERS STRUGGLE FOR LIFE IN THE WATER.

Front page of The Daily Mirror, *31 March 1915.*

lifeboats, issue lifebelts, soothe fellow passengers and 'when there was a moment to spare…went about, camera in hand, snapping pictures here and there…oblivious of the danger.' In an age when communications were relatively primitive, the immediacy of these images direct from the 'war zone' – especially of an event as shocking and controversial as this – made them highly prized, and Lacon capitalized on his foresight.

Less than two months later, U-20 sank the *RMS Lusitania* with the loss of more than 1,000 lives, including more than 120 US citizens, adding to already high levels of tension.

THE CONFLICT

All photographs were taken with Vest Pocket Kodak cameras between 1914 and 1918.

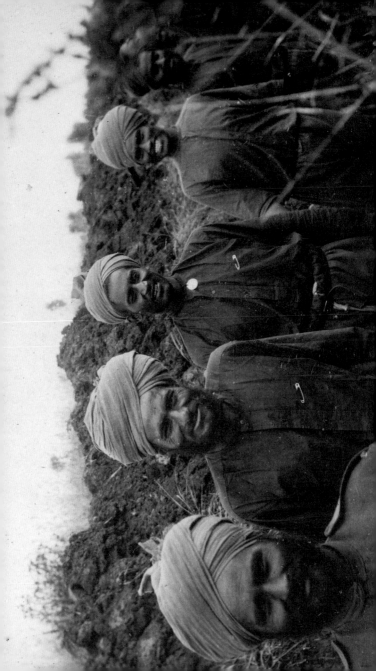

Sikh soldiers

Men of the 34th Sikh Pioneers of the Lahore Division in a trench in northern France smile for the camera of Second Lieutenant Charles Arthur Hepburn, then serving with the Royal Field Artillery. Men of the Indian Army were heavily involved in the Battle of Neuve Chapelle in March 1915.

'It will be difficult for anyone to survive and come back safe and sound from the war.... The bullets and cannon-balls come down like snow.'

—Letter from a Garhwali soldier, serving in France, to his father, 14 January 1915

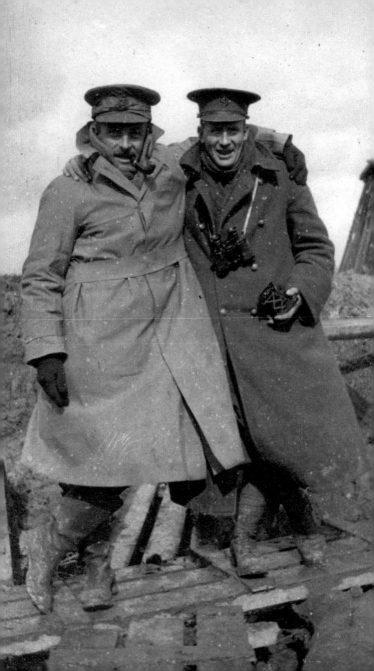

'We were all informed…
cameras were forbidden
and that any man who
had a camera…after
twenty-four hours would
be court-martialled.'

—Captain Harry Trounce, 181st Tunnelling Company, Royal Engineers

Happy snappers

Wrapping up against the cold in trenches south of Armentières in early 1915, Lieutenant Noel Sim (left) of 2nd Battalion, York and Lancaster Regiment, is snapped with Second Lieutenant John Archibald Angus, who clutches his trusty VPK in his left hand. Both men had cameras and probably had a fellow officer use Sim's camera to take the picture. Both men survived the war.

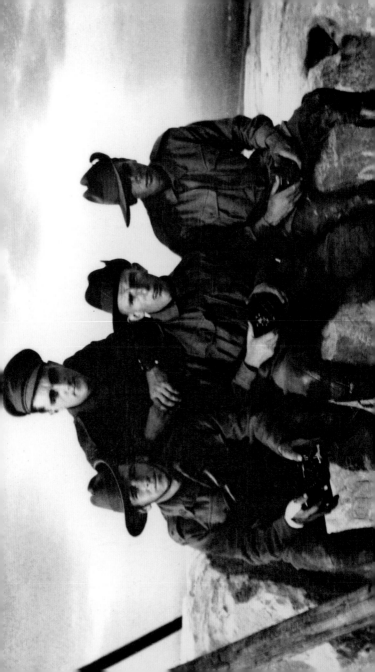

Giza

Gunner Maurice Thompson (standing) poses for posterity with three 'mates' holding cameras at the top of the Great Pyramid of Giza in Egypt, sometime during the winter of 1915–1916; a VPK is visible at the right. Thompson was seriously wounded on 29 April 1918 and died the same day. A tobacco tin – inscribed with the word 'FILMS' – was found on his body containing 89 negatives taken with his VPK Autographic camera. Thompson is buried in Ebblinghem Military Cemetery, between St Omer and Hazebrouck in France.

'We are camped in the Valley of the Pyramids with two of the big Pyramids in sight. They are an enormous size — a wonderful piece of work.'

—Sapper Ernest Charles Tubbenhauer, Mena Military Camp, Egypt, 14 December 1915

THE CONFLICT

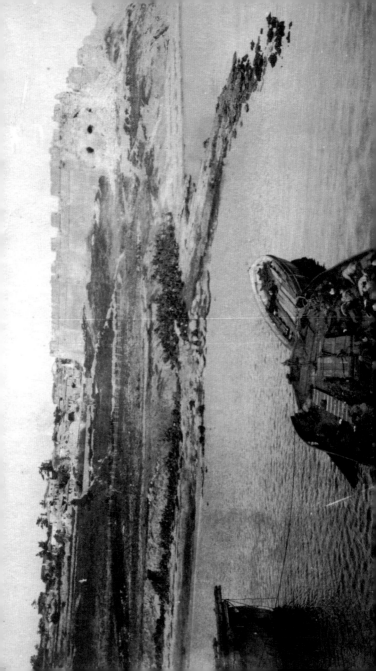

'Man after man behind
me was shot down but
they never wavered....
I stepped on the second
lighter and looked around
to find myself alone.'

—Captain Guy Geddes, 1st Battalion, Royal Munster Fusiliers, April 1915

View from the Clyde

Sometime around 8.00am on 25 April 1915 – the day of the Gallipoli landings – Lieutenant Cecil Newton Graham of the Royal Naval Air Service Armoured Car Squadron, took three photographs from the bows of the grounded collier SS River Clyde on V Beach. Men of the 1st Battalion, Royal Dublin Fusiliers can be seen – still under fire – taking cover under a bank beneath the menacing fort of Sedd-el-Bahr. Wounded and dying men of the 1st Battalion Royal Munster Fusiliers can be seen lying on board a lighter in the foreground.

THE CONFLICT

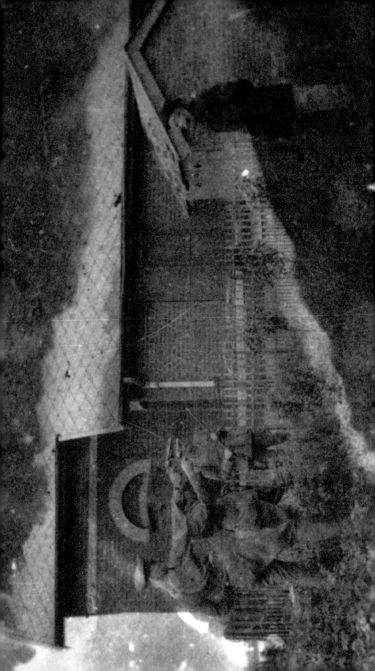

Blindfold and alone

A rare and chilling photograph of what appears to be the summary execution of a suspected spy by two British army officers with service revolvers. People, location and date are unknown.

'A Belgian settler…was tried by the French, and convicted of trafficking with the enemy… [He] owned a white horse, and was commonly said to have used it according to a code… the coincidence of a white horse… and the shelling of a near-by battery was apt to be thought significant.'

—Captain James Churchill Dunn, Royal Army Medical Corps, 11 November 1914

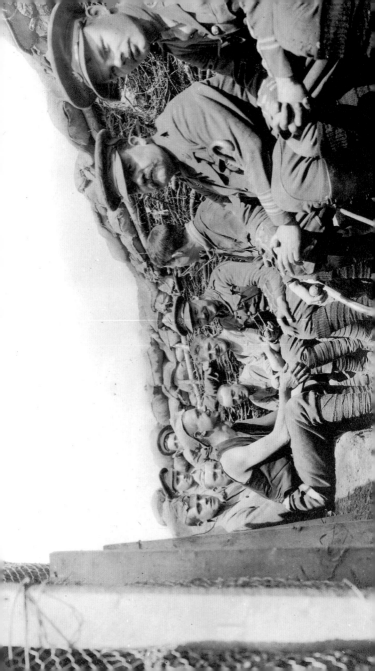

'[We are] a quaint medley...and we have been through such times together that we know each other pretty well... The commanding officer seems to trust us all implicitly. We get it in the neck now and then, but he gives us carte blanche in the trenches.'

—Captain Hugh Montagu Butterworth, 9th Battalion, the Rifle Brigade, 6 September 1915

Flouting the ban

Officers and men – including Lieutenant Colonel Charles Fox (second from right), the commanding officer of the 1/5 York and Lancaster Regiment – appear relaxed as Captain Harry Colver records a moment of informality in the trenches near Fleurbaix in France, May 1915. This photograph was taken several weeks after the British Army had banned cameras.

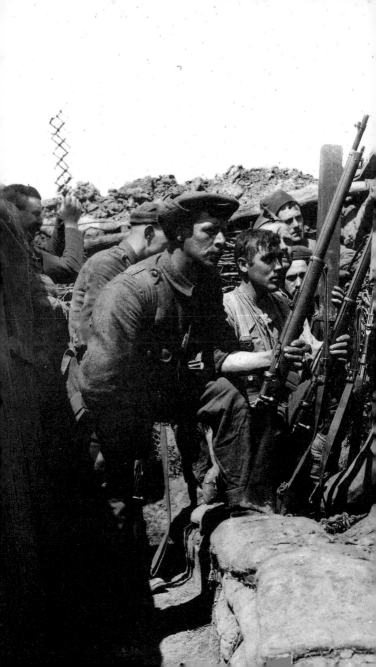

'My platoon — some of the best.'

—Captain George Hewitt, officer commanding C Company, 1/5 Battalion, York and Lancaster Regiment

Trench tableau

Looking more like mountain brigands than British soldiers, these Territorial Force soldiers of the 1/5 Battalion, York and Lancaster Regiment, were arranged in a suitably aggressive pose by officer and keen amateur photographer Captain Harry Colver in May 1915. On the left, Captain Hugh Parry Smith studies the German lines in the Fleurbaix sector with a trench periscope. They are armed with 'Long' Lee Enfield rifles, not the Short Magazine Lee Enfields of the regulars.

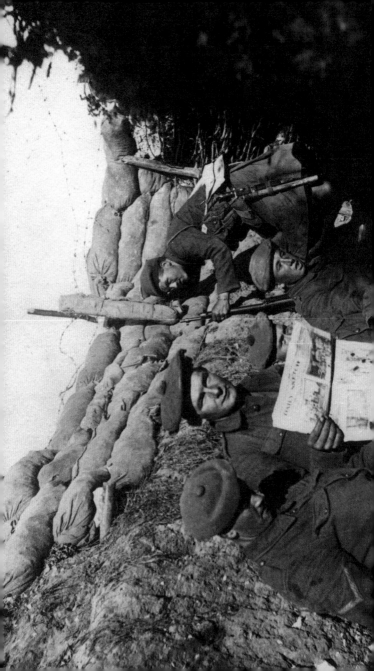

Seaforth Soldiers

An anonymous member of the 6th (Morayshire) Battalion, The Seaforth Highlanders took this trench snap following the battalion's move to the Somme front in the summer of 1915. Somehow a copy found its way back to Scotland and into the *Northern Scot* newspaper in March 1916 along with the following caption: 'Our readers will be interested in the above picture, which shows us a group of the 1/6th Seaforth Highlanders in the trenches. This, we believe, is one of the first photographs which has been published showing the Morayshires in the actual fighting line. The boys seem to be putting in the time with some degree of nonchalance. On the extreme left Lance Corporal Charles M'Donald, Elgin, is busily engaged writing in a notebook, probably to someone at home who will be very glad to receive his letter. Next to him we have Private Adam Wood, Elgin, who is of a literary turn of mind, judging from the newspaper [*Daily Sketch*] in his hand. Over the corner of the paper Private J Patience, Avoch, is peeping as if he didn't want the cameraman to know that he was with the Morayshires! Private Fraser, Moycroft, is meditating profoundly, while Private J M'Guiness, Elgin, is keeping a watchful eye on the enemy through the periscope.' The reference to Private Patience 'peeping' was perhaps due to the fact that he came from Avoch, on the Black Isle, and had originally served with his local Territorial Force battalion, the 1/4 (Ross-shire) Battalion, Seaforth Highlanders.

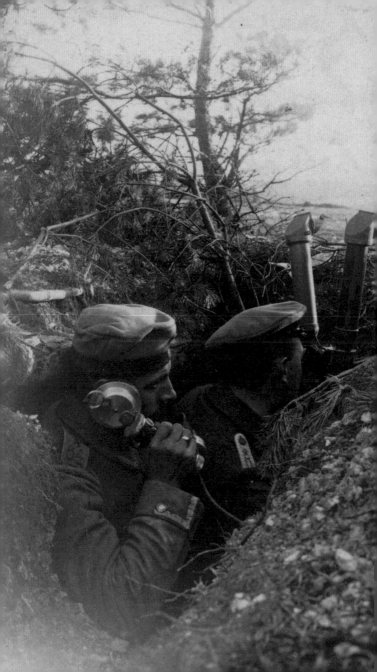

Observation

Leutnant der Reserve Kämpf of
4 Battery, Reserve Field Artillery
Regiment 23 is pictured by an
anonymous photographer operating
the battery's *Scherenfernrohr* (scissors peri-
scope) in a cramped forward
observation post in the Moronvilliers
sector of the Champagne front. The
Unteroffizier telephonist behind him
is a transferee who is still wearing the
shoulder straps of his old unit, Field
Artillery Regiment 64.

'This evening... [bullets]
were forever whizzing past
us... you could tell that the
English were in the front
line again; the French don't
shoot so wildly.'

—Hans Brückner, German Reserve Infanterie Regiment 242, letter to his father, 29 January 1915

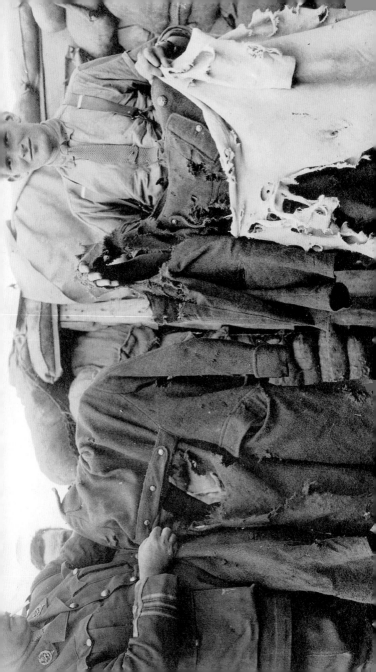

Near miss

Captain Harry Colver urges fellow officers Major Charles Willis (left) and Lieutenant Archie Paul to display a greatcoat, tunic and undershirt shredded by fragments from a German shell that smashed into an unoccupied dugout held by 1/5 Battalion, York and Lancaster Regiment, in trenches near Fleurbaix, France, in May 1915.

'You soon got used to the different noises; you could hear 'em all coming. Their 'whizz bangs' were 'laid' just on top of our trenches …all you heard was 'bang, whoosh, bang.'

—Private Frank Lindley, 14th Battalion, York and Lancaster Regiment (2nd Barnsley Pals)

THE CONFLICT

Over the top

Images of men attacking over the parapet and moving forward into no-man's land are extremely rare. Here, a soldier of the London Rifle Brigade stands above the parapet to photograph men of his battalion going over the top and disappearing into a cloud of poison gas, fumes and dust thrown up by bursting shells on the opening day of the battle of Loos, 25 September 1915.

Ahead the clouds of smoke, sluggish low-lying fog and fumes of bursting shells, thick in volume…formed a striking background for the soldiers…marching… towards the enemy's parapet.

—Private Patrick MacGill, stretcher bearer with 1/18th Battalion, London Regiment

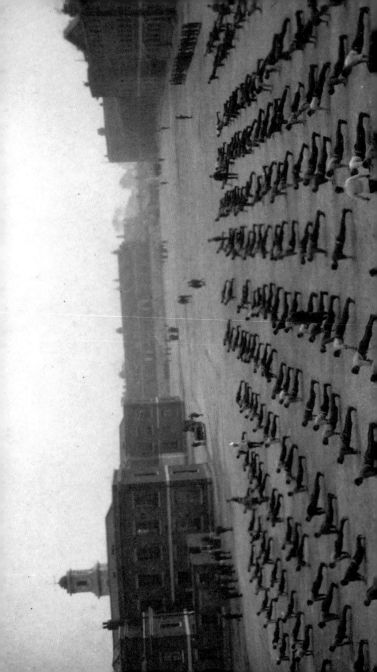

Swedish drill

An anonymous officer photographs men being put through their paces on the parade ground of an unknown barracks. This is one of a number of images taken from a collection belonging to an officer in the 11th Battalion, Devonshire Regiment.

'To say that we enjoyed the training would be far from the truth, it resolved itself to one drab round of drill, drill, drill, intermixed with trench digging, route marching, kit inspections and guards. After some eight months of training we began to shape into something like soldiers.'

—Private Harry Drinkwater, 15th Battalion, Royal Warwickshire Regiment

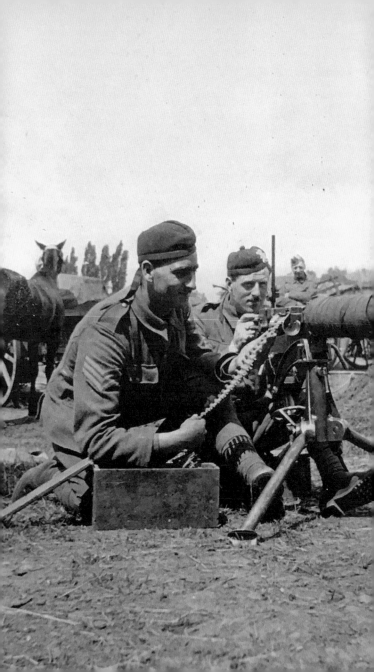

Weapons training

This rare photograph of men of the 1/9 Battalion, Highland Light Infantry, training on the Vickers machine gun is taken from album of images snapped in Britain and France by Corporal Harold Wilson, an 'other rank' as opposed to an officer. Harold Wilson went to France on 5 November 1914 and was later commissioned as an officer into the 6th Battalion of the Cameron Highlanders.

'He kept the spare lock. . .in his trouser pocket to keep it warm, as the cold stiffened the oil on the moving parts. Every half-hour he whipped the lock out of the gun and substituted the warm one from his pocket.'

—Private George Coppard, 6th Battalion, Queen's Royal West Surrey Regiment, October 1915

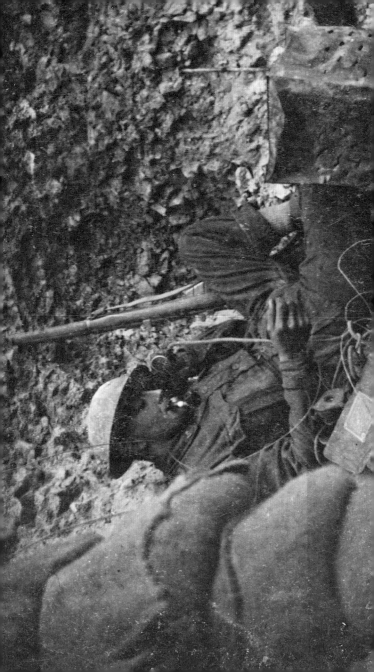

Trench telephone

A signaller – thought to be Australian – sheltering under the parapet of a trench surrounded by sandbags and an improvized brazier while he tries to get a message through, somewhere on the Somme in 1916. With his pipe in mouth he appears relatively relaxed, completely unconcerned about being party to what is, by 1916, a court martial offence.

'From [the] observation post we arranged our guns by telephone... we chose a ... garish villa as our target, and succeeded in hitting it. After we had ranged six guns on this villa ... a pathetic piece of furniture that looked like a four-post bed protruded through a jagged gap between the shattered windows.'

—Captain the Honourable Herbert Asquith, Royal Field Artillery, March 1918

"Teddy"

Mascot of the 3rd Divisional Supply Column

*How those poor
dumb animals
suffered in a world of
madness made by us.*

—Private John Schofield, 8th Battalion, West Yorkshire Regiment (The Leeds Rifles)

Poor bear

'Teddy', the Koala mascot of the
Australian 3rd Divisional Supply Column
was snapped with a VPK belonging to
Private Rupert Arthur Dunne, a driver
with the 3rd Divisional Supply Column,
in Melbourne, Australia in 1916 before
his unit set sail for Britain. Sadly, Teddy
did not survive for long after his supply
of eucalyptus (gum) leaves ran out on
the voyage to England. Some of Dunne's
photographs were printed as postcards
and sent home to family members.

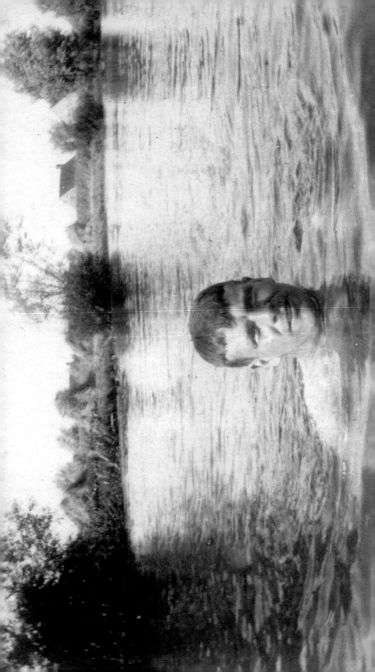

Taking a dip

Private John Polgreen of the 1/28th (County of London) Battalion (Artist's Rifles) enjoys what, according to his caption, was a birthday dip on 25 July 1915 while his battalion operated as an Officers' Training Corps near St Omer in France. Commissioned into the 9th Battalion the Rifle Brigade, Polgreen was wounded on the Somme in 1916 but survived the war.

'I managed to get in a bathe.... After three days without washing in the trenches it was an indescribable joy diving in.'

—Lieutenant Frederick Septimus Kelly, Hood Battalion, Royal Naval Division, 19 August 1915

'The conductor's bell was still functioning and, as the boys clambered aboard... rang the bell. "Do you stop at the Savoy Hotel?" ...and the reply was always, "No, sir! Can't afford it!"'

—Rifleman Joe Hoyle, 13th Battalion, the Rifle Brigade, Summer 1917

Bus wreck

A war-ravaged, B-type London omnibus lies at the side of the road near Bucquoy in France, sometime in 1917. These vehicles were used to transport troops on the Western Front as early as the autumn of 1914.

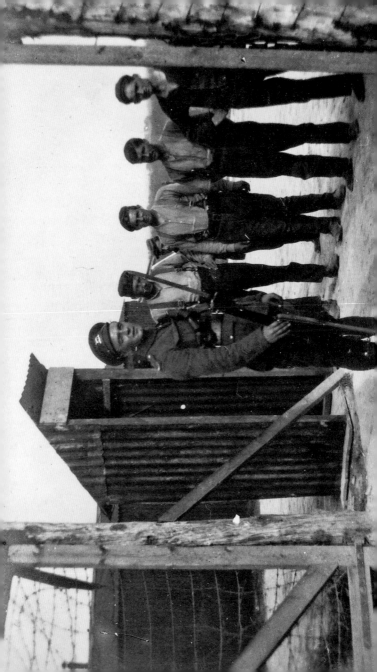

Captivity

A lone sentry of the Queen's
Regiment, sporting three overseas
service chevrons on his sleeve, guards
a surly group of German soldiers
in a prisoner of war compound at
Longueau, east of Amiens in 1918.

*'You fought desperately…before
you were taken prisoner… In
the fighting you were a hero.
And now before the eyes of the
enemy — for whom you were and
are always the dirty Boche, the
bestial Hun…will you be slack
or foolish?'*

—Translation of a German leaflet on correct behaviour under interrogation, 1918

THE CONFLICT

IMAGE CREDITS

Whilst every effort has been made to seek appropriate permissions for illustrations and quotations if, inadvertently, these have been overlooked then I, or the publishers, should be pleased to hear from copyright holders. If any errors or omissions remain, then they are entirely due to oversights on my part.

9 Shutterstock.

11 Robin Shields.

15 Jon Cooksey.

16 Courtesy and copyright of Jos Erdkamp.

19 Jon Cooksey.

23 Jon Cooksey.

25 Richard van Emden.

26 Courtesy and copyright of Jos Erdkamp.

28 Courtesy and copyright of Jos Erdkamp.

29 Courtesy and copyright of Jos Erdkamp.

30 Richard van Emden.

33 Lancashire Infantry Museum, Preston.

34 Imperial War Museum.

37 Andrew Lucas.

39 Webb Album (1915) No.3 Outpost. Auckland War Memorial Museum, Tamaki Paenga Hira.

40 Jon Cooksey.

42 Imperial War Museum.

43 Richard van Emden.

45 Peter Barton.

47 Peter Barton.

49 Australian War Memorial.

50 Imperial War Museum.

53 Alamy/ John Frost Newspapers.

55 Courtesy and copyright of Jos Erdkamp.

56 Richard van Emden.

58 Richard van Emden.

60 Australian War Memorial.

62 Richard van Emden.

64 Imperial War Museum.

66 Jon Cooksey.

68 Jon Cooksey.

70 Richard van Emden.

72 Andrew Lucas.

74 Jon Cooksey.

76 Richard van Emden.

78 Richard van Emden.

80 Richard van Emden.

82 Richard van Emden.

84 Australian War Memorial.

86 Richard van Emden.

88 Richard van Emden.

90 Richard van Emden.

BIBLIOGRAPHY

Books

Peter Barton, *The Battlefields of the First World War* (Constable and Robinson, 2005).

Brian Coe, *Kodak Cameras – The First Hundred Years* (Hove Books, 2003).

Jon Cooksey, *Flanders 1915 – Images of War* (Pen and Sword, 2004).

Peter Pedersen, *Anzac Treasures – The Gallipoli Collection of the Australian War Memorial* (Murdoch Books, 2014).

H D Trounce, *Fighting the Boche Underground* (Scribner's Sons, 1918).

Richard van Emden, *Tommy's War – The Western Front in Soldiers' Words and Photographs* (Bloomsbury, 2014).

Richard van Emden, *The Somme – the Epic Battle in the Soldiers' own Words and Photographs* (Pen and Sword, 2016).

Articles

Helen J Carter, 'First Casualties: Finding Second Lieutenant A F J Sang – Intelligence Corps,' *Stand To! The Journal of the Western Front Association*, 104 (September 2015) pp.82–85.

George Layne (ed.) 'The Vest Pocket Kodak Camera,' *Journal of the International Historical Kodak Society*, Vol. 1 No. 2 (August 1988) pp.2–11.

Eaton S Lothrop Jr. 'Henry J Gaisman and the Story of Kodak's Autographed Photographs,' *Photographica World,* No. 114, (2005) pp.11–19.

Bob White, 'Before the Vest Pocket Kodak,' *Photographica World,* No. 143 (2013) pp.55–57.

Online

Hilary Roberts, 'Photography,' *1914-1918 Online International Encyclopedia of the First World War*, http://encyclopedia.1914-1918-online.net/article/photography#GND_118561634

INDEX

ACKNOWLEDGMENTS

This book could not have been written without the wholehearted support, help and advice of many people with a deep knowledge of, and expertise in, their particular field.

Richard van Emden has been an enthusiastic supporter from the outset. He is an acknowledged authority on the First World War and his knowledge of the photographic legacy left by Britain's 'small' amateur army of soldier photographers is unrivalled. His insightful foreword sets the tone for the rest of the book.

I also extend my grateful thanks to other friends and colleagues who are recognized authorities in their area of research. Dr Peter Pedersen – recently retired from his post at the Australian War Memorial in Canberra – advised on the historical significance of key images taken by Australian troops during the Gallipoli campaign. Author and broadcaster Peter Barton's encyclopaedic knowledge of rare German images and documents helped me to work towards balancing the narrative. Images from his personal collection also enabled me to illustrate the section on the Christmas Truce, perhaps the single most extraordinary and iconic event captured on film during the First World War. Andrew Lucas also allowed me to use several striking German images for which, many thanks. My chum Peter Hart granted permission to quote from his wonderful book *Gallipoli*.

Sections on the technical aspects of the VPK camera would have been spare without the unstinting support of Jos Erdkamp in the Netherlands. Jos sent much invaluable technical material and read key sections for accuracy. I am grateful too for his generosity in allowing me to reproduce items from his collection of original Kodak publications.

Derek Bird allowed me use extracts from his research into photographs of the Seaforth Highlanders, which brought them to life once again on the page and Terry Dean and Jane Davies lent their support by granting permission to use the wonderfully evocative images taken by Major Thomas Stanton of the 1st East Lancashire Regiment held in the Lancashire Infantry Museum archive.

My wife Heather has 'taken up the slack' at home yet again, despite her own busy schedule, and my daughter Georgia – now studying herself – has chipped in with valuable practical advice. What would I do without them?

If anyone else who has been kind enough to help me in any way has been missed, please be assured that this has not been intentional. To those affected, please accept my sincere apologies.